THE ROYAL HORTICULTURAL SOCIETY
DIARY 2012

Commentary by
Brent Elliott

Illustrations from
the Royal Horticultural Society's
Lindley Library

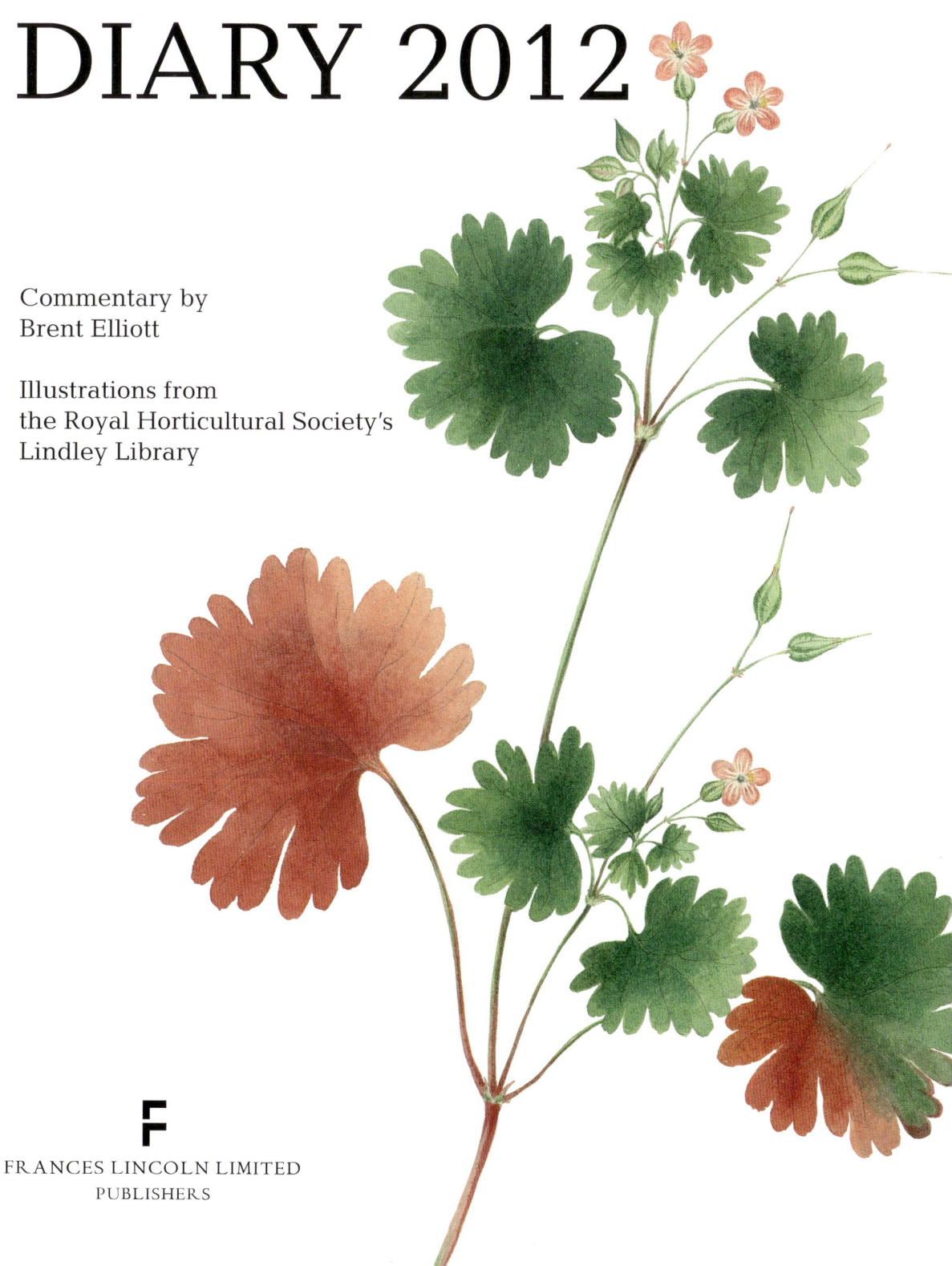

F

FRANCES LINCOLN LIMITED
PUBLISHERS

Frances Lincoln Limited
4 Torriano Mews
Torriano Avenue
London NW5 2RZ
www.franceslincoln.com

The Royal Horticultural Society Diary 2012
Copyright © Frances Lincoln limited 2011
Text and illustrations copyright © the Royal Horticultural Society 2011 and printed under licence granted by the Royal Horticultural Society, Registered Charity number 222879/SC038262.
For more information visit our website
or call 0845 130 4646
An interest in gardening is all you need to enjoy being a member of the RHS.
Website: www.rhs.org.uk

First Frances Lincoln edition 2011

Astronomical information © Crown Copyright. Reproduced by permission of the Controller of Her Majesty's Stationery Office and the UK Hydrographic Office (www.ukho.gov.uk)

Every effort is made to ensure calendarial data is correct at the time of going to press but the publisher cannot accept any liability for any errors or changes.

All rights reserved. No part of this publication may be reproduced, stored in a retrieval system or transmitted, in any form, or by any means, electronic, mechanical, photocopying, recording or otherwise, without either prior permission in writing from the publishers or a licence permitting restricted copying. In the United Kingdom such licences are issued by the Copyright Licensing Agency, Saffron House, 6–10 Kirby Street, London EC1N 8TS.

A catalogue record for this book is available from the British Library

ISBN: 978-0-7112-3195-5

Printed in China

1 2 3 4 5 6 7 8 9

Front cover Original artwork by Cynthia Newsome-Taylor, reproduced as a plate in the book *The Treasury of Flowers* by Arthur Hellyer (1961).
Back cover Watercolour by Caroline Maria Applebee, painted 1840, showing *Campanula rapunculus* and *Phaseolus multiflorus* with a garden tiger moth (*Arctia caja*).
Title page Coloured drawing of *Lythrum salicaria*, undated, by Lilian Snelling.
Overleaf Watercolour on vellum of *Camellia japonica* by Margaret Meen, dated 1789.

RHS FLOWER SHOWS 2012
Regrettably Flower Show dates are no longer included in this diary. Show date changes after publication caused confusion.
The following dates were correct at the time of going to press but, due to circumstances beyond our control, show dates often change in the interim period so *please confirm before travelling*. Neither the RHS or the publisher can accept liability for any errors.
The Chelsea Flower Show (May 22–26 2012), **Hampton Court Palace Flower Show** (July 3–8 2012) and **Tatton Park Flower Show** (July 18–22 2012), **Cardiff Flower Show** (April 20–22 2012), **Malvern Flower Shows** (May 10–13 and Sept 29–30 2012) and themed London Shows throughout the year.

RHS Flower Show Information
Can be found by visiting www.rhs.org.uk or telephoning the **24-hour Flower Show Information Line (020 7649 1885)**

CALENDAR

JANUARY
M	T	W	T	F	S	S
						1
2	3	4	5	6	7	8
9	10	11	12	13	14	15
16	17	18	19	20	21	22
23	24	25	26	27	28	29
30	31					

FEBRUARY
M	T	W	T	F	S	S
	1	2	3	4	5	
6	7	8	9	10	11	12
13	14	15	16	17	18	19
20	21	22	23	24	25	26
27	28	29				

MARCH
M	T	W	T	F	S	S
			1	2	3	4
5	6	7	8	9	10	11
12	13	14	15	16	17	18
19	20	21	22	23	24	25
26	27	28	29	30	31	

APRIL
M	T	W	T	F	S	S
						1
2	3	4	5	6	7	8
9	10	11	12	13	14	15
16	17	18	19	20	21	22
23	24	25	26	27	28	29
30						

MAY
M	T	W	T	F	S	S
	1	2	3	4	5	6
7	8	9	10	11	12	13
14	15	16	17	18	19	20
21	22	23	24	25	26	27
28	29	30	31			

JUNE
M	T	W	T	F	S	S
				1	2	3
4	5	6	7	8	9	10
11	12	13	14	15	16	17
18	19	20	21	22	23	24
25	26	27	28	29	30	

JULY
M	T	W	T	F	S	S
						1
2	3	4	5	6	7	8
9	10	11	12	13	14	15
16	17	18	19	20	21	22
23	24	25	26	27	28	29
30	31					

AUGUST
M	T	W	T	F	S	S
	1	2	3	4	5	
6	7	8	9	10	11	12
13	14	15	16	17	18	19
20	21	22	23	24	25	26
27	28	29	30	31		

SEPTEMBER
M	T	W	T	F	S	S
					1	2
3	4	5	6	7	8	9
10	11	12	13	14	15	16
17	18	19	20	21	22	23
24	25	26	27	28	29	30

OCTOBER
M	T	W	T	F	S	S
1	2	3	4	5	6	7
8	9	10	11	12	13	14
15	16	17	18	19	20	21
22	23	24	25	26	27	28
29	30	31				

NOVEMBER
M	T	W	T	F	S	S
			1	2	3	4
5	6	7	8	9	10	11
12	13	14	15	16	17	18
19	20	21	22	23	24	25
26	27	28	29	30		

DECEMBER
M	T	W	T	F	S	S
					1	2
3	4	5	6	7	8	9
10	11	12	13	14	15	16
17	18	19	20	21	22	23
24	25	26	27	28	29	30
31						

CALENDAR 2013

JANUARY
M	T	W	T	F	S	S
	1	2	3	4	5	6
7	8	9	10	11	12	13
14	15	16	17	18	19	20
21	22	23	24	25	26	27
28	29	30	31			

FEBRUARY
M	T	W	T	F	S	S
				1	2	3
4	5	6	7	8	9	10
11	12	13	14	15	16	17
18	19	20	21	22	23	24
25	26	27	28			

MARCH
M	T	W	T	F	S	S
				1	2	3
4	5	6	7	8	9	10
11	12	13	14	15	16	17
18	19	20	21	22	23	24
25	26	27	28	29	30	31

APRIL
M	T	W	T	F	S	S
1	2	3	4	5	6	7
8	9	10	11	12	13	14
15	16	17	18	19	20	21
22	23	24	25	26	27	28
29	30					

MAY
M	T	W	T	F	S	S
	1	2	3	4	5	
6	7	8	9	10	11	12
13	14	15	16	17	18	19
20	21	22	23	24	25	26
27	28	29	30	31		

JUNE
M	T	W	T	F	S	S
					1	2
3	4	5	6	7	8	9
10	11	12	13	14	15	16
17	18	19	20	21	22	23
24	25	26	27	28	29	30

JULY
M	T	W	T	F	S	S
1	2	3	4	5	6	7
8	9	10	11	12	13	14
15	16	17	18	19	20	21
22	23	24	25	26	27	28
29	30	31				

AUGUST
M	T	W	T	F	S	S
			1	2	3	4
5	6	7	8	9	10	11
12	13	14	15	16	17	18
19	20	21	22	23	24	25
26	27	28	29	30	31	

SEPTEMBER
M	T	W	T	F	S	S
						1
2	3	4	5	6	7	8
9	10	11	12	13	14	15
16	17	18	19	20	21	22
23	24	25	26	27	28	29
30						

OCTOBER
M	T	W	T	F	S	S
	1	2	3	4	5	6
7	8	9	10	11	12	13
14	15	16	17	18	19	20
21	22	23	24	25	26	27
28	29	30	31			

NOVEMBER
M	T	W	T	F	S	S
				1	2	3
4	5	6	7	8	9	10
11	12	13	14	15	16	17
18	19	20	21	22	23	24
25	26	27	28	29	30	

DECEMBER
M	T	W	T	F	S	S
						1
2	3	4	5	6	7	8
9	10	11	12	13	14	15
16	17	18	19	20	21	22
23	24	25	26	27	28	29
30	31					

INTRODUCTION

The drawings reproduced in this diary tell the story of the development of botanical art as a career for women. Flower painting had become an accepted skill for women during the eighteenth century, and during the second half of the century various women entered flower paintings in public exhibitions, but publication was generally speaking not an option.

The earliest of the artists shown here is Margaret Meen, about whose life little is known. She was born in Bungay, Suffolk, but moved to London in order to teach flower painting; in 1781 the botanist T. J. Woodward wrote to the nurseryman William Curtis asking him to provide specimens for her to draw. Between 1775 and 1785 she exhibited at the Royal Academy, and until 1810 she exhibited at the Watercolour Society. In 1790 she published two parts of a project book entitled *Exotic Plants from the Royal Gardens at Kew*, each part containing four hand-coloured engravings. This was the first British botanical publication by a woman since Elizabeth Blackwell's *Curious Herbal* over half a century earlier. The next female botanical artist to reach print, Mary Lawrance, whose *Collection of Roses* appeared nine years later, acted as her own publisher.

Exhibiting paintings might result in sales; otherwise private patronage was the main source of income for female artists. To this was added in the nineteenth century the patronage of learned societies. Two of the artists represented here were hired by the Horticultural Society of London in the 1820s to paint fruit varieties and other plants. Of Barbara Cotton little is known, beyond the fact that she exhibited at the Royal Academy between 1815 and 1822. But Augusta Innes Withers (c.1791–1876) rose to a position of eminence, as Flower Painter in Ordinary, first to Queen Adelaide and then to Queen Victoria. That she already had a sense of her prowess by the age of thirty is apparent from the grumbles in the minutes of the Society's Council about the high fees she charged. In addition to her work for the Society, she also illustrated the *Pomological Magazine* that John Lindley, the Society's Assistant Secretary, published between 1828 and 1830, as well as James Bateman's immense *Orchidaceae of Mexico and Guatemala* (1837–43) and E. G. Henderson's *Illustrated Bouquet* (1857–64). She nonetheless spent her last years in poverty as a result of her husband's bad financial management.

Amateur flower painters, who did not seek to publish their work, continued to work. Lydia Penrose (1787–1842) is known only from an album of flower drawings now in the RHS Lindley Library, entitled "Flora Devoniensis", depicting wild flowers of Devon. Caroline Maria Applebee (c.1799–1854) appears to have been the daughter of a wealthy middle-class family whose conservatories and greenhouses provided the plants and flowers she painted. The RHS Lindley Library holds a collection of her drawings made between 1808 and 1852.

Private and society patronage continued to be the main route to financial success for female botanical artists. Nelly Roberts (1872–1959) was hired by the RHS to paint the portraits of all orchids that received awards from the Orchid Committee; she began work in 1897, and finally retired only in 1954, on which occasion she was awarded the Veitch Memorial Medal. In over half a century, she painted over 4500 orchid portraits for the Society, as well as, on occasion, duplicate copies for the exhibitors.

By the twentieth century, with a flourishing book trade and a range of magazines ready to publish illustrations, the prospects for female illustrators had improved. Lilian Snelling (1879–1972) worked first for a private patron, H. J. Elwes of Colesbourne, then moved to Scotland to work as an artist for the Royal Botanic Garden, Edinburgh. In 1921 she was hired by the RHS to illustrate *Curtis's Botanical Magazine*, and over the next thirty years produced over 740 plant portraits for that work alone. In addition, she provided plates for Arthur Grove's *Supplement to Elwes' Monograph of the Genus Lilium* (1933–40) and Stern's *Study of the Genus Paeonia* (1946). She was awarded the Victoria Medal of Honour in 1955.

Vera Higgins (1892–1968) was not a professional artist, but a Scientific Officer at the National Physical Laboratory; she wrote several books on cacti and succulents, and translated others. For a few years during the Second World War she was the editor, simultaneously, of the Royal Horticultural Society's *Journal*, the Alpine Garden Society's *Quarterly Bulletin*, and the *Journal* of the Cactus and Succulent Society of Great Britain: small wonder that she was awarded the Victoria Medal of Honour in 1946. Some of her drawings appeared in her books on cacti, but she made no attempt to publish those of orchids and other subjects.

The most recent artist in this volume, Cynthia Newsome-Taylor (1906–83), originally trained as a fashion designer and worked in various fields of art, beginning a career as a freelance horticultural illustrator in 1945. The collection of her work that she bequeathed to the RHS begins in 1950, and includes drawings made for Arthur Hellyer's *Shrubs in Colour* and other works; she also illustrated books by J. S. Dakers, C. G. Haysom (his classic 1957 work on *Florists' Auriculas*), Violet Stevenson, and her husband, the garden writer Peter R. S. Hunt.

From private patronage, through the patronage of societies, to independent commercial employment: so have the prospects for female botanical artists developed over the course of the last two centuries.

Brent Elliott
THE ROYAL HORTICULTURAL SOCIETY

DECEMBER – JANUARY

WEEK 1

26 *Monday*

Boxing Day (St Stephen's Day)
Holiday, UK, Republic of Ireland,
USA, Canada, Australia and New Zealand

27 *Tuesday*

Holiday, UK, Australia and New Zealand

28 *Wednesday*

29 *Thursday*

30 *Friday*

31 *Saturday*

New Year's Eve

1 *Sunday*

First Quarter
New Year's Day
Holiday, Republic of Ireland

Watercolour on paper entitled *Odontoglossum Schlieperianum*
by Vera Higgins, dated August 1937.

Odontoglossum Schlieperianum

week 2 # JANUARY

Holiday, UK, USA, Canada, Australia and New Zealand — *Monday* 2

Holiday, Scotland and New Zealand — *Tuesday* 3

Wednesday 4

Thursday 5

Epiphany — *Friday* 6

Saturday 7

Sunday 8

Original artwork by Cynthia Newsome-Taylor, reproduced as a plate in the book *The Treasury of Flowers* by Arthur Hellyer (1961).

JANUARY

WEEK 3

9 *Monday* — *Full Moon*

10 *Tuesday*

11 *Wednesday*

12 *Thursday*

13 *Friday*

14 *Saturday*

15 *Sunday*

Watercolour on vellum of *Portlandia grandiflora* by Margaret Meen, dated 1789.

week 4 # JANUARY

Last Quarter
Holiday, USA (Martin Luther King's Birthday) — *Monday* 16

Tuesday 17

Wednesday 18

Thursday 19

Friday 20

Saturday 21

Sunday 22

Coloured drawing of *Iris* 'Mrs Barnard' by Lilian Snelling, dated 2–4 January 1952. Made from a specimen provided by Mrs Stevenson of Balesmead, it shows the development of the flower over a three-day period.

JANUARY

WEEK 5

23 *Monday* — New Moon / Chinese New Year

24 *Tuesday*

25 *Wednesday*

26 *Thursday* — Holiday, Australia (Australia Day)

27 *Friday*

28 *Saturday*

29 *Sunday*

Watercolour on board of *Vanda coerulea* var. 'Bodnant Rose' by Nelly Roberts, from a specimen exhibited by Lady Aberconway (First Class Certificate, November 1921).

Strelitzia Reginae
Pentandria Monogynia

WEEK 6

JANUARY – FEBRUARY

Monday 30

First Quarter

Tuesday 31

Wednesday 1

Thursday 2

Friday 3

Saturday 4

Sunday 5

Watercolour on paper of *Strelizia reginae* by Margaret Meen, c.1790.

FEBRUARY

WEEK 7

6 Monday

Accession of Queen Elizabeth II (Diamond Jubilee)
Holiday, New Zealand (Waitangi Day)

7 Tuesday

Full Moon

8 Wednesday

9 Thursday

10 Friday

11 Saturday

12 Sunday

Watercolour by Caroline Maria Applebee, painted c.1814, showing *Crocus olivieri*, *Prunus tenella*, *Galanthus nivalis*, and *Omphalodes verna*.

Sophonites grandiflora

WEEK 8

FEBRUARY

Monday 13

Last Quarter
St Valentine's Day

Tuesday 14

Wednesday 15

Thursday 16

Friday 17

Saturday 18

Sunday 19

Watercolour on paper of *Sophronites grandiflora* by Vera Higgins, painted in the 1930s.

FEBRUARY

WEEK 9

20 Monday — Holiday, USA (Washington's Birthday)

21 Tuesday — *New Moon* / Shrove Tuesday

22 Wednesday — Ash Wednesday

23 Thursday

24 Friday

25 Saturday

26 Sunday

Original artwork by Cynthia Newsome-Taylor, reproduced as a plate in the book *The Treasury of Flowers* by Arthur Hellyer (1961).

Amaryllideæ.
Narcissus.
N. Pseudo-narcissus.
Common Daffodil, Lent Lily.

"Southover". Burwash
Sussex

WEEK 10

FEBRUARY – MARCH

Monday 27

Tuesday 28

Wednesday 29

First Quarter
St David's Day

Thursday 1

Friday 2

Saturday 3

Sunday 4

Coloured drawing of *Narcissus pseudonarcissus* by Lilian Snelling, undated, but painted at 'Southover', Burwash, Sussex.

MARCH

WEEK 11

5 *Monday*

6 *Tuesday*

7 *Wednesday*

8 *Thursday* — *Full Moon*

9 *Friday*

10 *Saturday*

11 *Sunday*

Watercolour by Caroline Maria Applebee, painted 1822, showing *Erysimum cheiri* and *Matthiola incana*.

WEEK 12 MARCH

Commonwealth Day *Monday* 12

Tuesday 13

Wednesday 14

Last Quarter *Thursday* 15

Friday 16

St Patrick's Day
Holiday, Republic of Ireland *Saturday* 17

Mother's Day, UK *Sunday* 18

Watercolour on board of *Cattleya Gladiator*, painted by Nelly Roberts (Award of Merit, July 1929).

MARCH

WEEK 13

19 *Monday* — Holiday, Northern Ireland (St Patrick's Day)

20 *Tuesday* — Vernal Equinox (Spring begins)

21 *Wednesday*

22 *Thursday* — New Moon

23 *Friday*

24 *Saturday*

25 *Sunday* — British Summer Time begins

Coloured drawing of *Fritillaria latifolia* by Lilian Snelling, made for H. J. Elwes of Colesbourne in April 1915.

Cheiranthus Cheiri. Wall flower.
Class Tetradynamia. Order Siliquosa.

week 14

MARCH – APRIL

Monday 26

Tuesday 27

Wednesday 28

Thursday 29

First Quarter

Friday 30

Saturday 31

Palm Sunday

Sunday 1

Watercolour on paper of *Cheiranthus cheiri*, from the album "Flora Devoniensis" by Lydia Penrose.

APRIL

WEEK 15

2 *Monday*

3 *Tuesday*

4 *Wednesday*

5 *Thursday* — Maundy Thursday

6 *Friday* — *Full Moon*
Good Friday
Holiday, UK, Canada, Australia and New Zealand

7 *Saturday* — Holiday, Australia (Easter Saturday)
First Day of Passover (Pesach)

8 *Sunday* — Easter Sunday

Watercolour by Caroline Maria Applebee, showing *Clarkia pulchella*, *Dianthus chinensis*, and *Tradescantia virginiana*.

Aquilegia vulgaris. Columbines
Class Polyandria. Order Pentagynia.

WEEK 16

APRIL

Easter Monday
Holiday, UK (exc. Scotland), Republic of Ireland, Australia and New Zealand

Monday 9

Tuesday 10

Wednesday 11

Thursday 12

Last Quarter

Friday 13

Saturday 14

Sunday 15

Watercolour on paper of *Aquilegia vulgaris*, from the album "Flora Devoniensis" by Lydia Penrose.

APRIL

WEEK 17

16 Monday

17 Tuesday

18 Wednesday

19 Thursday

20 Friday

21 Saturday

New Moon
Birthday of Queen Elizabeth II

22 Sunday

Coloured drawing of *Paeonia clusii* by Lilian Snelling, made in May 1931 for a plate in Sir Frederick Stern's *Study of the Genus Paeonia* (1946).

Paeonia cretica
May 20·1931
Lilian Snelling

WEEK 18

APRIL

St George's Day — Monday 23

Tuesday 24

Holiday, Australia and New Zealand (Anzac Day) — Wednesday 25

Thursday 26

Friday 27

Saturday 28

First Quarter — Sunday 29

Watercolour on paper of *Orchis* sp., from the album "Flora Devoniensis" by Lydia Penrose.

APRIL – MAY

WEEK 19

30 *Monday*

1 *Tuesday*

2 *Wednesday*

3 *Thursday*

4 *Friday*

5 *Saturday*

6 *Sunday*

Full Moon

Watercolour on paper of *Ribes sanguineum*, the red-flowering currant, by Augusta Innes Withers, made for the Horticultural Society in 1829.

Mrs Withers Delt.
1829.

Aquilegia Vulgaris *Columbines.*

week 20 MAY

Early Spring Bank Holiday, *Monday* 7
UK and Republic of Ireland

Tuesday 8

Wednesday 9

Thursday 10

Friday 11

Last Quarter *Saturday* 12

Mother's Day, USA, Canada, *Sunday* 13
Australia and New Zealand

Watercolour on paper of *Aquilegia vulgaris*, from the album "Flora Devoniensis" by Lydia Penrose.

MAY

WEEK 21

14 *Monday*

15 *Tuesday*

16 *Wednesday*

17 *Thursday* — Ascension Day

18 *Friday*

19 *Saturday*

20 *Sunday* — New Moon

Coloured drawing of *Allium wallichii* by Lilian Snelling, painted at Colesbourne, September 1915.

Allium Wallichii
Coleorton. Sept 2nd 1915.

WEEK 22

MAY

Holiday, Canada (Victoria Day) *Monday* 21

Tuesday 22

Wednesday 23

Thursday 24

Friday 25

Saturday 26

Whit Sunday (Pentecost) *Sunday* 27
Feast of Weeks (Shavuot)

Watercolour by Caroline Maria Applebee, painted 1828, showing *Dianthus caryophyllus* 'Scarlet Flake' and *Jasminum officinale*.

MAY – JUNE

WEEK 23

28 *Monday*

First Quarter
Holiday, USA (Memorial Day)

29 *Tuesday*

30 *Wednesday*

31 *Thursday*

1 *Friday*

2 *Saturday*

Coronation Day

3 *Sunday*

Trinity Sunday

Coloured drawing of *Meconopsis cambrica*, dated July 1950, by Lilian Snelling, made from a specimen found at Lynmouth.

Meconopsis cambrica
Welsh poppy.

Lilian Snelling

Geranium s[...]
Blood-red C[...]
Port Seaton, ScoT[...]

week 24 # JUNE

Spring Bank Holiday, UK
Holiday, Republic of Ireland
Holiday, New Zealand (The Queen's Birthday) | *Monday* 4

Holiday, UK (The Queen's Diamond Jubilee) | *Tuesday* 5

Wednesday 6

Corpus Christi | *Thursday* 7

Friday 8

The Queen's Official Birthday (subject to confirmation) | *Saturday* 9

Sunday 10

Coloured drawing of *Geranium sanguinea* [sic = *sanguineum*], dated 1918, by Lilian Snelling, made from a specimen found at Port Seaton, Scotland.

JUNE

WEEK 25

11 Monday

Last Quarter
Holiday, Australia (The Queen's Birthday)
subject to confirmation

12 Tuesday

13 Wednesday

14 Thursday

15 Friday

16 Saturday

17 Sunday

Father's Day, UK, Canada and USA

Original artwork by Cynthia Newsome-Taylor, reproduced as a plate in the book
The Treasury of Flowers by Arthur Hellyer (1961).

WEEK 26

JUNE

Monday 18

New Moon

Tuesday 19

Summer Solstice (Summer begins)

Wednesday 20

Thursday 21

Friday 22

Saturday 23

Sunday 24

Watercolour on paper of *Cypripedium album*, undated, by Margaret Meen.

JUNE – JULY

WEEK 27

25 *Monday*

26 *Tuesday*

27 *Wednesday* — First Quarter

28 *Thursday*

29 *Friday*

30 *Saturday*

1 *Sunday* — Canada Day, Canada

Watercolour on paper of *Rosa canina*, from the album "Flora Devoniensis" by Lydia Penrose.

Rosa *cinnamomea*
Class Icosandria

Cinnamon Rose
Order Polygynia

Augusta Innes Withers
1825

WEEK 28 JULY

Holiday, Canada (Canada Day) Monday 2

Full Moon Tuesday 3

Holiday, USA (Independence Day) Wednesday 4

Thursday 5

Friday 6

Saturday 7

Sunday 8

Watercolour on paper of 'Knight's Scarlet Fleshed' Strawberry, made by Augusta Innes Withers for the Horticultural Society in 1825.

JULY

WEEK 29

9 Monday

10 Tuesday

11 Wednesday — Last Quarter

12 Thursday — Holiday, Northern Ireland (Battle of the Boyne)

13 Friday

14 Saturday

15 Sunday — St Swithin's Day

Coloured drawing of *Meconopsis grandis* by Lilian Snelling, made while working at the Edinburgh Botanic Garden in June 1916.

Meconopsis grandis.
Edin. June 1916

Antirrhinum majus
Class *Didynamia*

Greater Snapdragon
Order Angiospermi

week 30

JULY

Monday 16

Tuesday 17

Wednesday 18

New Moon

Thursday 19

First Day of Ramadân

Friday 20

Saturday 21

Sunday 22

Watercolour on paper of *Antirrhinum majus*,
from the album "Flora Devoniensis" by Lydia Penrose.

JULY

WEEK 31

23 *Monday*

24 *Tuesday*

25 *Wednesday*

26 *Thursday* *First Quarter*

27 *Friday*

28 *Saturday*

29 *Sunday*

Original artwork by Cynthia Newsome-Taylor, reproduced as a plate in the book
The Treasury of Flowers by Arthur Hellyer (1961).

Lilium Bellingham Hybrid C. Newsome-Taylor

week 32

JULY – AUGUST

Monday 30

Tuesday 31

Wednesday 1

Full Moon Thursday 2

Friday 3

Saturday 4

Sunday 5

Watercolour on vellum of *Clematis purpurea* by Margaret Meen, dated 1789.

AUGUST

WEEK 33

6 Monday │ Summer Bank Holiday, Scotland
Holiday, Republic of Ireland

7 Tuesday

8 Wednesday

9 Thursday │ Last Quarter

10 Friday

11 Saturday

12 Sunday

Coloured drawing of *Kniphofia galpinii* by Lilian Snelling,
the original drawing for plate 8928 of *Curtis's Botanical Magazine* (1938).

Kniphofia Galpini

B. Cotton, Pinx.t 1822.

WEEK 34

AUGUST

Monday 13

Tuesday 14

Wednesday 15

Thursday 16

New Moon

Friday 17

Saturday 18

Eid-al-Fitr (end of Ramadan)

Sunday 19

Watercolour on paper by Barbara Cotton of the Peach 'Vanguard',
made for the Horticultural Society in 1822.

AUGUST

WEEK 35

20 *Monday*

21 *Tuesday*

22 *Wednesday*

23 *Thursday*

24 *Friday* — *First Quarter*

25 *Saturday*

26 *Sunday*

Watercolour on paper of *Malva moschata*, from the album "Flora Devoniensis" by Lydia Penrose.

WEEK 36

AUGUST – SEPTEMBER

Summer Bank Holiday, UK (exc. Scotland) — Monday 27

Tuesday 28

Wednesday 29

Thursday 30

Full Moon — *Friday* 31

Saturday 1

Sunday 2

Watercolour on vellum of *Passiflora misera* by Margaret Meen, dated 1789.

SEPTEMBER

WEEK 37

3 Monday Holiday, USA (Labor Day)
 Holiday, Canada (Labour Day)

4 Tuesday

5 Wednesday

6 Thursday

7 Friday

8 Saturday Last Quarter

9 Sunday

Original artwork by Cynthia Newsome-Taylor, reproduced as a plate in the book
The Treasury of Flowers by Arthur Hellyer (1961).

Cynthia Newsome Taylor

WEEK 38

SEPTEMBER

Monday 10

Tuesday 11

Wednesday 12

Thursday 13

Friday 14

Saturday 15

New Moon

Sunday 16

Watercolour on board of ×*Brassocattleya* Helios, painted by Nelly Roberts (Award of Merit, October 1926).

SEPTEMBER

WEEK 39

17 Monday Jewish New Year (Rosh Hashanah)

18 Tuesday

19 Wednesday

20 Thursday

21 Friday

22 Saturday *First Quarter*
Autumnal Equinox (Autumn begins)

23 Sunday

Watercolour by Caroline Maria Applebee, painted *c*.1814, showing *Callistephus chinensis* and *Coreopsis tinctoria*.

WEEK 40

SEPTEMBER

Monday 24

Tuesday 25

Day of Atonement (Yom Kippur)

Wednesday 26

Thursday 27

Friday 28

Michaelmas Day

Saturday 29

Sunday 30

Coloured drawing of *Castilleja miniata* by Lilian Snelling, made for H. J. Elwes of Colesbourne in June 1916.

OCTOBER

WEEK 41

1 *Monday*

Holiday, Australia (Labour Day) subject to confirmation
First Day of Tabernacles (Succoth)

2 *Tuesday*

3 *Wednesday*

4 *Thursday*

5 *Friday*

6 *Saturday*

7 *Sunday*

Watercolour on paper of the 'Cannon Hall Muscat' Grape, made by Augusta Innes Withers for the Horticultural Society in 1826.

WEEK 42

OCTOBER

Last Quarter
Holiday, USA (Columbus Day)
Holiday, Canada (Thanksgiving)

Monday 8

Tuesday 9

Wednesday 10

Thursday 11

Friday 12

Saturday 13

Sunday 14

Original artwork by Cynthia Newsome-Taylor, reproduced as a plate in the book
The Treasury of Flowers by Arthur Hellyer (1961).

OCTOBER

WEEK 43

15 *Monday* — New Moon

16 *Tuesday*

17 *Wednesday*

18 *Thursday*

19 *Friday*

20 *Saturday*

21 *Sunday*

Watercolour on board of *Dendrobium* Othello 'Colossus', painted by Nelly Roberts (Award of Merit, February 1900).

Barbara Cotton. Pinx't 1822

WEEK 44

OCTOBER

First Quarter
Holiday, New Zealand (Labour Day)

Monday 22

Tuesday 23

United Nations Day

Wednesday 24

Thursday 25

Friday 26

Saturday 27

British Summer Time ends

Sunday 28

Watercolour on paper of the 'Wellington' apple, made by Barbara Cotton for the Horticultural Society in 1822.

OCTOBER – NOVEMBER

WEEK 45

29 *Monday* Full Moon
Holiday, Republic of Ireland

30 *Tuesday*

31 *Wednesday* Hallowe'en

1 *Thursday* All Saints' Day

2 *Friday*

3 *Saturday*

4 *Sunday*

Watercolour on paper of *Quercus robur*, from the album "Flora Devoniensis" by Lydia Penrose.

cus robur.
Monoecia.

Common British Oak.
Order Polyandria.

week 46

NOVEMBER

Guy Fawkes | *Monday* 5

Tuesday 6

Last Quarter | *Wednesday* 7

Thursday 8

Friday 9

Saturday 10

Remembrance Sunday | *Sunday* 11

Watercolour on board of a flower of ×*Brassocattleya* Lisette, painted by Nelly Roberts (Award of Merit, September 1920).

NOVEMBER

WEEK 47

12 Monday Holiday, USA (Veterans Day)
Holiday, Canada (Remembrance Day)

13 Tuesday New Moon

14 Wednesday

15 Thursday Islamic New Year begins (subject to sighting of the moon)

16 Friday

17 Saturday

18 Sunday

Watercolour on paper of the apple 'Bell's Scarlet',
made by Barbara Cotton for the Horticultural Society in 1822.

WEEK 48

NOVEMBER

Monday 19

First Quarter *Tuesday* 20

Wednesday 21

Holiday, USA (Thanksgiving Day) *Thursday* 22

Friday 23

Saturday 24

Sunday 25

Watercolour on paper of *Notocactus apricus* by Vera Higgins, dated c.1960.

NOVEMBER – DECEMBER

WEEK 49

26 *Monday*

27 *Tuesday*

28 *Wednesday* — Full Moon

29 *Thursday*

30 *Friday* — St Andrew's Day

1 *Saturday*

2 *Sunday* — First Sunday in Advent

Original artwork by Cynthia Newsome-Taylor, reproduced as a plate in the book *The Treasury of Flowers* by Arthur Hellyer (1961).

b.Newsome-Taylor

WEEK 50

DECEMBER

Monday 3

Tuesday 4

Wednesday 5

Last Quarter

Thursday 6

Friday 7

Saturday 8

Hannukah begins

Sunday 9

Watercolour on board of ×*Brassocattleya* John Linford, painted by Nelly Roberts (Award of Merit, March 1930).

DECEMBER

WEEK 51

10 *Monday*

11 *Tuesday*

12 *Wednesday*

13 *Thursday* *New Moon*

14 *Friday*

15 *Saturday*

16 *Sunday*

Watercolour on paper of *Aloe variegata* by Vera Higgins, dated c.1937.

oe variegata.

WEEK 52

DECEMBER

Monday 17

Tuesday 18

Wednesday 19

First Quarter

Thursday 20

Winter Solstice (Winter begins)

Friday 21

Saturday 22

Sunday 23

Watercolour by Caroline Maria Applebee, painted c.1814, showing *Cotoneaster microphyllus*, *Platycladus orientalis*, and *Viscum album*.

DECEMBER

WEEK 53

24 *Monday* Christmas Eve

25 *Tuesday*

Christmas Day
Holiday, UK, Republic of Ireland, USA,
Canada, Australia and New Zealand

26 *Wednesday*

Boxing Day (St Stephen's Day)
Holiday, UK, Republic of Ireland,
Australia and New Zealand

27 *Thursday*

28 *Friday* Full Moon

29 *Saturday*

30 *Sunday*

Watercolour of *Ilex aquifolium* (holly) by Caroline Maria Applebee, painted c.1833.

DECEMBER JANUARY

Week 1

31 *Monday* — New Year's Eve

1 *Tuesday* — New Year's Day
Holiday, UK, Republic of Ireland, USA, Canada,
Australia and New Zealand

2 *Wednesday* — Holiday, Scotland and New Zealand

3 *Thursday*

4 *Friday*

5 *Saturday* — Last Quarter

6 *Sunday* — Epiphany